P9-CKG-817

Make It Till You Make It

40 Myths and Truths About Creating

BRENDAN LEONARD

Copyright © 2016 Brendan Leonard/Semi-Rad Media

All rights reserved.

ISBN: 978-0692813058

WHAT THIS BOOK IS ABOUT

This book is very brief and intended to get you to stop procrastinating and start creating.

I wrote it because I believe in expression, from graffiti murals to multi-million-dollar municipally-funded sculptures, Oscar-winning feature films and short Vimeo videos produced by a crew of one person, prize-winning books and self-published ebooks, smartphone photos and large-format prints. I believe in art maybe more than anything else, and I think the world can always use more of it.

I meet people every year who need more encouragement and fewer excuses. People who have a passion for photography or painting or writing or music or poetry, but can't seem to make time for it in their lives.

No one who's making creative things for a living (part-time or full-time) is any more talented than those people who wish they could be more creative—they just want to create more than they

want to do other things.

If you opened this book, it's probably because you're interested in doing something creative and putting it out there for other people to enjoy. If you need permission to get started, I hope this provides it. It's not a long book, and you may not even need to read the whole thing before you set it down to pick up your guitar, camera, notebook, or whatever it is you use to express what's in your head.

I don't care if you read this all the way through or not—as long as you start doing whatever it is that brings you joy. And maybe pass this book on to someone else who you think could use it.

WHO I AM

I can't tell you how to make it big, but I can tell you a few things about making it small and loving it. I have written a handful of books and a few hundred articles for magazines and web sites, and produced and directed a few short films—and that's my job, because after working a number of office jobs for eight years, I was able to transition into writing and filmmaking full-time a few years ago. Doing that requires some creativity, some ambition, some marketing and promotion—but mostly wanting to do it and after several years, still wanting to do it every day. So I thought I'd share what I've learned. If you'd like to know more about me, you can find me at Semi-Rad.com.

40 MYTHS AND TRUTHS ABOUT CREATING

1.

YOU DON'T NEED ANYONE'S PERMISSION, OR MONEY, TO DO IT.

A young writer friend once told me that it was her goal to have a book published in two years. I said she should absolutely do it, and that it only cost me about $100 to self-publish my first book. She said she had difficulty making time to work on a (theoretically) non-paying project like a book, and that she had thought about starting a crowdfunding campaign to finance it. I told her that if she really believed in the book project, she would just do it, and not try to raise money to "get paid" for it before she'd even started the writing process.

Art that you produce without a paycheck is 100 percent inspiration and drive, and although most writers, photographers, and filmmakers might hesitate to admit it, once someone is paying you for your art, it starts to feel a little bit like work—and the fire to create is somewhat compromised. Once

you owe it to someone else, the book (or short film or photo essay or art installation), becomes something you have to do, and maybe less something you want to do.

To start a project just because you want to create it is to harness that fire that makes you want to create in the first place. It stays pure, because the only stakeholders in the artistic process are you and the audience you imagine seeing (and hopefully loving) the finished product. No one changes the direction of your vision, and more importantly, no one can reject the project or tell you it's a terrible idea while you're working on it.

Fifty years ago, to write a story and get it in front of an audience, you had to submit it to a magazine or a newspaper or a publisher. To make a song or a movie, you had to go through a record label or studio. There are far fewer barriers to entry these days: Filmmakers can make and edit short movies on phones, writers can start free blogs, and photographers can take photos and upload them to the internet immediately. No one can reject your dream, and no one can keep you from putting it out there. Of course, you're also not getting paid for it—yet.

2.

MOST OF IT IS NOT INSPIRED.

Most of it will feel like work. For every sentence that comes into your head as if placed there by a lightning bolt from the gods of prose, you will have to write 100 others that feel as inspired as shoveling snow out of your driveway so you can drive to work on a Monday morning.

3.

IT'S OK TO DO SOMETHING OTHER THAN ART FOR WORK.

As great as quitting your job to follow your dreams sounds (and looks on social media), it simply won't work for a lot of people. A "real job" can be a blessing. It takes a certain type of person to want to create full-time, and even when that person decides to do it, half of their "work" time will be spent on non-creative bullshit—writing e-mails, making phone calls, scheduling meetings with people, doing all the things necessary to sell their art and make a living at it (so they don't have to work a "real job").

If waiting tables pays your rent so you can paint during the hours you're not at work, do it, and don't be ashamed of it. If wedding photography pays the bills and gives you the freedom to take one trip to Nepal each year to shoot the photos that inspire you, you're winning.

4.

IF YOU'RE HONEST WITH YOURSELF, YOU BELIEVE IN YOUR ART AT LEAST ENOUGH TO DO IT.

In a 2015 interview on *WTF with Marc Maron*, actor and writer Jason Segel said: "I think that anyone who's a performer is a very unique personality type, in that you believe somewhere that what you have to express artistically is worthy of people paying money for and being quiet and listening to."

Do you believe your art is worth something, whether it's a million dollars or just the time it would cost someone to experience whatever you're creating? You can answer that question either "yes" or "not quite yet," but you can't answer it "no." Because somewhere deep down, you want someone else to consume or experience what you're working on, whether it's one person or one million people.

5.

DON'T GET HUNG UP ON THE MEDIUM.

Casey Neistat, who made most of his living on commercial projects before becoming famous as a renegade filmmaker, identifies himself with the somewhat underwhelming title of "YouTuber." Several of his short films have been viewed millions of times, but he holds true to what he spends most of his time doing: recording and editing vlogs, or video blogs, for YouTube. He found something he enjoyed, and poured his daily efforts into it, whether it made him money or not. And of course, it eventually did.

We live in an era of media where change is nearly constant. Be open to new (and old) mediums, and don't be afraid to try something out—you might just fall in love with it and find a way to make money off it. The money always follows the media that has an audience, whether it's advertising in newspapers, Super Bowl commercials, or product

endorsements on Instagram. If you create something that people love, and you have a big enough audience, someone will pay you to give them access to that audience. If you think something is silly ("an app that limits videos to six seconds?") or outdated ("no one reads books anymore"), the chances are very good that someone is proving you wrong by reaching thousands of people or making thousands of dollars with that exact medium.

Sure, plenty of photographers would say the ultimate success is getting their photos published in *National Geographic*, but plenty of photographers are making a living and finding artistic fulfillment by selling prints or reaching hundreds of thousands of people online.

6.

IT'S OK TO LEARN THE BASICS OF A CRAFT BY IMITATING OTHERS' WORK. BUT AS LONG AS YOU IMITATE OTHERS, YOU DON'T HAVE YOUR OWN VOICE.

Thousands of writers' first efforts no doubt resemble authors we've all read—Hunter S. Thompson, Chuck Klosterman, Ernest Hemingway. Certain photography rules exist because they work for everyone, regardless of style. Understanding why something is good is a great place to start creating—and imitating something generally regarded as high quality is certainly way more likely to be successful than imitating something that no one likes. But to flourish as a creator, you have to develop your own style, because anyone with any sort of taste will recognize an imitator. Imitation may be the most sincere form of flattery, but it's also one of the surest ways to get ignored. If people want to watch a Wes Anderson movie,

they'll watch a Wes Anderson movie, not an imitation of a Wes Anderson movie.

7.

MAKE GIFTS FOR YOUR FRIENDS.

Your friends are your first and best audience, and your window to understand what other people will like when it comes to art.

Instead of worrying about the "quality" of a story, or the technical aspects of a photo or painting, imagine what you want people to get out of what you're creating. Think of the people most familiar to you when you start to build your idea, rather than "the world." The world is a huge audience with lots of wildly differing needs—some men just want to watch action movies, but other men don't mind a good emotionally open story. You may be able to reach both, but it's probably better to concentrate on one group and start there. And your friends, or people who at least think somewhat like you, are a great place to start.

We should always think about why we're making what we're making. You can make a painting that

communicates something about your body image issues, and if it helps other people understand or deal with their body image issues, you've created something good for someone else. If you write a song about heartbreak and other people who have had their hearts broken can relate to it, you've succeeded.

In his 2009 YouTube video, *The Gift of Gary Busey*, bestselling writer John Green dispensed this advice to people who asked him how to become a writer:

"Don't make stuff because you want to make money — it will never make you enough money. And don't make stuff because you want to get famous — because you will never feel famous enough. Make gifts for people — and work hard on making those gifts in the hope that those people will notice and like the gifts. Maybe they will notice how hard you worked, and maybe they won't — and if they don't notice, I know it's frustrating. But, ultimately, that doesn't change anything — because your responsibility is not to the people you're making the gift for, but to the gift itself."

8.

GIVE IT AWAY UNTIL THEY CAN'T LIVE WITHOUT IT.

When you're first starting out and you have no audience, you can be proud or humble about it. You can tell yourself, "I'm a [artist/writer/photographer/singer]; I'm not doing this for free," and wait until you can sell your song or photos or story, or you can take whatever chance you get to share your art with the world (open mics, selling art at farmer's markets, writing for low-paying publications, etc.) in hopes that the appropriate monetary compensation will come later. Russell Simmons, the hip hop promoter turned entrepreneur, has long preached the "give it away until they can't live without it" philosophy, in his 2011 book *Super Rich: A Guide to Having It All*, and on social media:

"Instead of keeping your gift locked in your heart until you 'find the right deal,' or get someone to 'pay me what I'm worth,' hand it over to the world.

Right now. Without a deal in place. Even without anyone paying you a dime. I realize that might sound counterintuitive, but trust me, giving away your gift is often what will help you get paid in the long run. That's because when you give your talent and gift to the world, the world becomes dependent on it. Isn't that really the idea behind a mixtape? You give people your music for free until they grow to love it so much they're willing to pay for it. Don't tell me that didn't work for 50 Cent or Lil Wayne. Well, it works in every other industry too. When you are prepared to give away your gift as soon as it's ready, you will always reap the rewards for that giving attitude later on."
—*Russell Simmons, Facebook, September 19, 2012*

Iconic pop art painter Keith Haring didn't just spring up on the New York art scene as a famous name from the beginning—he painted his unmistakable crawling babies and other designs on blank spaces reserved for ads in New York's subways. Nobody paid him to do that, but it eventually acted as a citywide advertising campaign for his brand and his art.

No matter the medium throughout time, word-of-mouth will always be the best advertising for your work. Haring understood that graffiti, although technically illegal, was the best way to get his work into the consciousness of everyone around New York. So he gave it away, and it didn't cost him anything but paint, and the risk of being arrested for writing graffiti.

9.

CREATIVITY CAN COST NOTHING BUT YOUR TIME, AND THAT TIME CAN BE THE TIME OF YOUR LIFE.

If you're not creating, your free time can become an endless search for something to distract you: a new movie to watch, a new game to play, a new TV show to binge-watch on Netflix, bouncing from one smartphone social media app to the next and back again looking for anything that will entertain you. Or, for probably very little or no money, you can create something.

Rapper, writer, and actor Ice Cube once said in an interview, "You're never poor if you're doing something creative." Buying and renting things to entertain you costs money. Making creative things can be free or inexpensive. The musicians who created hip hop started with no musical instruments besides turntables (which were up until that point devices for listening to recorded music, not making new music). Plenty of artists

have begun learning their craft starting with a pad and pencil.

10.

YOU'RE ONLY A STARVING ARTIST IF YOU'RE ACTUALLY MAKING ART WHILE YOU'RE STARVING.

If every day after you get off work, you're sitting in a bar telling someone about the book you'd like to write someday, you're full of shit. You're spending all your spare time doing something other than writing that book.

You don't necessarily have to have a monastic devotion to your art (although that's probably a very productive strategy), but don't bullshit yourself. The world is full of people who would love to do something cool "someday," but for a million reasons, they never even take the first step.

The fact is, it takes no mental or physical effort to have a dream, especially if you continually procrastinate the actual work it would take to realize that dream. Making something, on the other hand, and having the courage to put it out there,

will require hours of trying, fucking up, re-doing, worrying if it's good enough or true enough or exactly what you wanted to say in the first place, and more hours of trying, before you nervously send it out to whatever audience you believe needs it. And all that stuff is the scary part, which is why all those big ideas never get started in the first place and die at the bottom of a beer glass or under a pile of other stuff we think is "more important."

Hopefully you believe in yourself enough to at least try. Every starving artist who tries does so with at least some belief that one day, they won't starve as much to make their art, even if their paintings only sell for enough money to fund buying more canvases or brushes and keep their creative life going. As filmmaker and surf photographer Mickey Smith said in the film *Dark Side of the Lens*, "If I only scrape a living, at least it's a living worth scraping."

11.

WRITE WHAT YOU KNOW—ER, START WITH WHAT YOU KNOW.

The classic advice to beginning writers says to "write what you know," because it's the most believable. Obviously science fiction writers have ignored this for decades and had great success. I believe the advice should be "start with what you know," or the stories closest to your heart, or even closest to your house. Learn the basics of a craft trying something familiar—writing personal stories or a memoir, painting landscapes of scenes near where you live, writing songs about the things closest to your heart. You already know the language of familiar things, so start there.

Once you've acquired mastery of the elements of telling the "story" of something easier, branch out from there. Depicting something you have less knowledge of requires research, and that's an extra step (and sometimes the biggest step) in addition to knowing how to set a scene, or where to point a

camera.

Nas's 1994 album *Illmatic* is almost universally hailed as one of the greatest hip hop albums of all time (if not the greatest), and its subject matter barely covers anything outside New York City, and for the most part only the Queensbridge housing projects, where Nas grew up. It was what he knew, and his vision of life there was more vivid and intriguing than any other hip hop artist had ever communicated. Talking about his neighborhood, in the best way he knew how, vaulted him to stardom—and after that, of course, he traveled the world. But first, he wrote about what he knew best.

12.

DON'T TAKE CRITICISM PERSONALLY.

Especially on the internet. There seems to be a special breed of people whose only mission is to spend 10 seconds taking down something that took someone else days or months or years to create. They're toxic, angry, sad, insecure people, and they will find you someday, if your art reaches a big enough audience. People will tell you to develop a "thick skin," and you will, eventually—or rather, you'll learn to instantly dismiss criticism that has no constructive purpose.

Obviously there's a place for well-thought-out, informed criticism. If your film or book is being reviewed in the *New York Times*, you're aware of this (and you're probably not reading this book). But if you find yourself getting depressed because of a two-star Amazon.com review of your book, written by someone whose only other reviews are a toaster oven and an anti-itch ointment that didn't

work, remember how easy it is for anyone to criticize your artistic effort versus how hard it is to work up the courage to put something out there.

A scene in the movie *Birdman* gives some perspective: When first-time director Riggan Thomas confronts theater critic Tabitha Dickinson in a bar, she says she is going to "destroy" his play in her review, even though she hasn't seen it yet. Thomas, at the end of a brief diatribe, says, "You write a couple of paragraphs and you know what … none of this costs you fucking anything. You risk nothing. Nothing. Nothing. Nothing. Well I'm a fucking actor. This play cost me everything."

13.

IT'S OK TO FAKE IT UNTIL YOU MAKE IT (WITH HUMILITY).

You don't grow without taking risks, and at some point, someone will find your work, and say, "I liked what I saw of your last project. Could you do something like that, but way bigger, for me?" And you have two choices: You can take the safe route and say no, or you can take it on, lose some sleep worrying if you're good enough and they will actually like what you come up with. And that's one way to push yourself to improve: external motivation. If you wait until you're ready, you'll never be ready. No one is ever ready. If you're ready for whatever it is, whatever it is will be boring the entire time you're working on it.

14.

IF YOU WANT PEOPLE TO LIKE WHAT YOU DO, OR BENEFIT FROM YOUR ART IN SOME WAY, YOU WILL HAVE TO PUT IT OUT THERE.

To paraphrase a musician I knew once: The greatest guitar player in the entire world, whoever you think that is, left their basement practice space and stood up on a stage to share it at some point. Otherwise you'd never have heard what they were capable of, and they would only be the greatest guitar player in their entire basement. And they were probably nervous when they finally did leave their basement. See #13.

15.

JUST BECAUSE YOU PUT YOUR WORK OUT THERE, IT DOESN'T MEAN ANYONE'S GOING TO READ/WATCH/LISTEN TO IT.

Problem: "I'm just not comfortable promoting myself."

Solution: Can you afford an agent? No? Then get comfortable promoting yourself or don't be sad about no one ever seeing your art. Later, get an agent.

The world is a big, busy, distracting place, and no matter where you put your writing, photos, art, or films, the easiest thing for people to do is ignore it. You will eventually have to be at least somewhat comfortable (or resigned to) the idea of promoting your art. Everyone has a different comfort level with this. Some musicians don't mind playing their guitar in subway stations or street corners with a

hat sitting at their feet for patrons' donations. Some writers are terrified of reading their work at book signings.

The fairy tale of someone being "discovered" out of nowhere is rare. If you enjoy a piece of art, it's because at some point, whoever created it believed in it enough to get it in front of you, whether it's a song, a book, a painting, or a film. If you don't believe enough in your own art that you can look someone in the eye and tell them they might like it too, you won't get too far. If you only want to sell your jewelry on the internet and don't want to set up a booth at art festivals, don't—but know that you're missing out on a potential audience.

16.

MAKING SOMETHING WILL ALWAYS BE BETTER THAN WONDERING IF YOU COULD DO IT.

Thousands of people have committed themselves to National Novel Writing Month and hammered out 2,000 words per day to get a rough draft of a book. Very few of those books have ever been published, but all those people stepped up to the plate and found out they could do it, instead of daydreaming about it. Maybe that first 60,000-word effort taught them that they should never try to write another book, but more likely, it taught them a lot of things they could do next time, and gave them the confidence to try it again—albeit taking more than a month to write a first draft.

So try. Even if you think it sucks.

17.

YOU ARE PROBABLY ALWAYS GOING TO HATE MOST OF THE STUFF YOU DID TWO YEARS AGO.

No matter who you are, if you keep at it, you will always be a better painter/photographer/ musician/writer than you were yesterday. And reading what you wrote a year or two ago will probably be horrifying. Don't judge yourself too harshly, because someone probably loved your two-year-old work. Let them judge it. Dave Eggers in 2007 told Debbie Millman of *Design Matters* that he hated his book *A Heartbreaking Work of Staggering Genius*, published in 2000. But thousands of other people loved it—it was a No. 1 *New York Times* bestseller and a Pulitzer Prize finalist.

If you are making art, and continually trying to improve, of course you're going to look back and feel like your older stuff is less good. That's a good thing—hopefully it means you're getting better at what you do.

18.

YOU WILL PROBABLY SUCK AT FIRST.

Most people suck at first. It's a fact. Prodigies are rare in any pursuit. Even a first-time author whose book lands on the bestseller list wrote dozens of thousands of words before that one book was published. Don't feel entitled to success just because you tried really hard once and somehow it didn't work out the way you wanted it to.

Do this:

Try.

Suck.

Try again.

Suck again.

Study what makes other art good or successful,

refine your efforts, and try more.

Eventually you will suck less, and one day you will not suck at all.

19.

DON'T DO IT FOR THE MONEY.

Do it because it's in you and you have to get it out. If you believe in it enough to share it with the world, it's not for you—it's for other people.

And, only in fairly rare cases is the money ever worth the work you're going to put into it. There's a reason people's parents want them to grow up to have well-paying, secure jobs, not become writers and musicians and painters. Creative things don't make very many people rich, at least in the financial sense. If you're not one of the top, say, 300 musical acts in the world, is it worth it? It's up to you. Is success making $50,000 a year to play music, or making $50,000 a year to write books and magazine articles? If it is, you can do it and be rich, or at least "rich." But if you're only concerned with making a million dollars, you may have to adjust your expectations at some point.

The Rolling Stones didn't decide to become a band

and make music because they wanted to be rich and famous (although they did do both those things). After all these years, do you think they still play together because they still feel some need to get richer and more famous? Obviously only they can answer that on a personal level, but I'd bet they're still doing it because they still enjoy it in some way.

20.

YOUR NEXT GREAT PHOTO OR STORY OR FILM IS PROBABLY NOT GOING TO COME OUT OF A GLOWING SCREEN.

Sorry, everybody. Phones and tablets are great for a lot of things, but unless you're actively creating something on them, you're probably just sitting there like a zombie breathing through your mouth hoping that screen will bring up something that will entertain you for the next 20 to 2,000 seconds, and a few political articles, comment threads, memes, and cat videos later, suddenly you've lost an hour of time you could have spent making something.

Scrolling is procrastinating, and it's making you less interesting. You need stillness in order for your mind to create, so put down your phone, close your laptop, go for a walk, and when you come back, create whatever it is you're going to create.

21.

NOBODY IS GOING TO MAGICALLY BESTOW THE TITLE "ARTIST" ON YOU SOMEDAY.

Or "writer," or photographer, or musician, or filmmaker, or sculptor, or dancer, or actor. When you do it enough, you become it. So go do it, whatever it is. Write, photograph, play, shoot, sculpt, dance, or act. Do it until it's a bigger part of you than your job, or sleeping, or eating, and then you'll realize it's what you are, more than anything else.

22.

YOU ARE GOING TO GET REJECTED.

It's usually not you. You never know what that editor or casting director or gallery owner is thinking, or looking for. Sometimes it's a reason that makes no sense—maybe the magazine ran another story about the desert already this year and they have an unwritten quota of only one desert story per year, or maybe the casting director doesn't like brunettes because of an unfortunate dating experience in college 10 years ago, or maybe they burned their toast that morning before your audition, or maybe five minutes after your pitch e-mail was sent they accidentally deleted their entire e-mail inbox because they don't understand technology.

But sometimes it is you. Maybe you don't really understand that literary journal's audience or needs as well as you think you do, or maybe you didn't nail the reading because you didn't 100 percent identify with the role, or maybe your

paintings are a little too, say, abstract for the people who usually buy art from that particular gallery. Maybe your stuff isn't ready yet, even though you think it is, but in four months, it will be. Maybe that magazine will reject your story idea and you'll pitch it somewhere else a month later and see that, yes, it's a much better fit at the second magazine.

But sometimes it's not you. Sometimes people suck at answering e-mail. Sometimes they reject you because they're having a bad day and you happened to pitch them on the exact wrong day, lucky you. Sometimes people in gatekeeper positions don't know shit about good art, and they're only the editor or casting director because they're someone's brother-in-law. Sometimes people make terrible decisions for no reason (like that person who cut you off on the freeway last Wednesday). You will never know.

Keep trying. A hundred bestsellers got rejected by a hundred publishers each before they landed at the exact perfect place, and then some of those 99 publishers said, "Shit, we really blew it on that one." But that author kept trying, and because they did, thousands of people got to read a really good story.

23.

YOU WILL DOUBT YOURSELF.
PROBABLY ALWAYS.

Every creative (and probably everyone else doing anything that challenges them) experiences what's known as Impostor Syndrome—the phenomenon psychologists Pauline Clance and Suzanne Imes defined in the journal *Psychotherapy: Theory, Research and Practice* in 1978 as the feeling of "phoniness in people who believe that they are not intelligent, capable or creative despite evidence of high achievement."

So you're not the only one who's not sure you have what it takes—even author Maya Angelou has famously admitted a nagging fear that someone is going to come out of nowhere and revoke her "writer" title someday. Or, as bestselling author David Foster Wallace put it in the interviews that became the film *The End of the Tour*, "The more people think you're great, the bigger the fear of being a fraud is."

24.

ANY DAY, YOU CAN GET THAT ONE E-MAIL OR PHONE CALL OR TEXT MESSAGE THAT WILL CHANGE YOUR LIFE.

If you're doing everything you can—creating, working to get your stuff out there, finding new inspiration, connecting with other artists and people who get art in front of the public—you should believe that things will one day break for you. It may not be what you think it is: the lead role in a TV show, a New York publishing house offering you a six-figure advance, someone commissioning a job that will pay off your mortgage. But it will make things easier for you, and give you some validation that your work is going somewhere. When that message does come, give yourself a high-five for sticking with it.

25.

NO MATTER WHAT ANYONE SAYS, THEY DIDN'T GET THERE BY THEMSELVES.

Everyone who is successful in any way had a person somewhere who gave them a hand up, however small and unnoticed that was—an art gallery owner who gave an unknown artist their first show, a bar manager who let an unproven band on stage, a producer who gave a rapper a shot on a track. Any manager who hires a new employee is taking a chance on that person, and it's no different in the creative life. Snoop Dogg may have never become a famous rapper if a producer named Dr. Dre hadn't let him rap on a couple songs (first and less famous, "Deep Cover"), and Dr. Dre would never have been in the position to help Snoop Dogg if a couple people hadn't taken a chance on him early in his career—like his friend Eazy-E, who bankrolled N.W.A.'s first efforts, or Alonzo Williams, who bankrolled some of his early studio time.

So look for those opportunities, and when you have the chance, ask the appropriate people to help you out. A small risk or gamble on their part can turn out to be a big deal for both of you.

26.

DON'T THINK YOU NEED SOMEONE TO TAKE CARE OF YOUR BASIC NEEDS SO YOU CAN CONCENTRATE ON YOUR ART.

When I was in college, a successful full-time freelance writer told my magazine writing class the popular myth that "If you want to be a freelance writer, you need a trust fund or an understanding spouse with a good job."

Although it's obviously quite helpful, this is of course not 100 percent true. I worked full-time non-writing jobs for six years, writing in my spare time, before I had enough freelance work to quit my full-time job to pursue writing full-time. I'm not unique (but I am writing what I know, Rule #11). We're all busy, and we all work too much. But almost everyone has time for other things outside of work. If you make your art your "other thing," you can actually produce. If you put your art third in your

list of priorities behind watching football and binge drinking, your art might never get very far. If you believe in it, you'll make time.

27.

AT SOME POINT, YOU WILL HAVE TO SAY YES TO SOMETHING THAT TERRIFIES YOU.

It's scary to put your work out there, and it's even scarier to try to make a living making art, whatever it is. Putting a price on your paintings, announcing you've published a book, or negotiating a rate for a graphic design project, or anything like that can lead to a crisis of confidence and make anyone question their vision, talent, or worth as an artist. And when you've sold some work and you're starting to think about ditching your full-time job to try to make a living with your creative passion, it's even more terrifying. But everyone who pays rent (or a mortgage) for a roof over their head has that same crisis. What should you do? Believe in yourself. Sure, you may not sell a million albums, but can you figure out how to make $35,000 your first year after you quit your job?

In a 2014 commencement speech at Maharishi

University, Jim Carrey said:

"So many of us choose our path out of fear disguised as practicality. What we really want seems impossibly out of reach and ridiculous to expect, so we never dare to ask the universe for it. My father could have been a great comedian, but he didn't believe that was possible for him, and so he made a conservative choice. Instead, he got a safe job as an accountant, and when I was 12 years old, he was let go from that safe job and our family had to do whatever we could to survive.

I learned many great lessons from my father, not the least of which was that you can fail at what you don't want, so you might as well take a chance on doing what you love."

If you look around at all your favorite filmmakers, musicians, writers, and artists, at some point, they all (in Jim Carrey's words) asked the universe for it. You have to find the courage to do the same.

28.

THERE ARE NO PERFECT CONDITIONS FOR MAKING ART.

In an interview in the Fall 1969 issue of the *Paris Review*, author E.B. White said, "A writer who waits for ideal conditions under which to work will die without putting a word on paper."

If only you had a cabin in the woods, you'd write that novel you've always wanted to write. If only you could take a few weeks off work and go to that artist's retreat, you'd finally be able to concentrate on your painting without getting distracted by all the other things in your life. Or maybe when you have enough money to buy the right camera or lens or editing software.

Or maybe you just need one more cup of coffee before you get started. Or a different type of music. Or complete silence. Or a glass of wine. Or maybe it's too late in the day, and you should just watch some TV and get up early and work on your story

or book or painting or photography tomorrow, when you're fresh. Yeah, that's it.

Or, maybe you're full of shit. All those excuses don't produce anything besides more procrastination. People with drive don't make lists of obstacles—they ignore them. Malik Bendjelloul, whose documentary *Searching for Sugar Man* won an Oscar, ran out of money during production and filmed a few key shots on an iPhone, and finished the film. I'm sure he also put up with all kinds of other hardships that you and I can relate to, like running out of coffee, or not getting exactly eight hours of sleep one or two nights.

29.

IT'S NOT THE CAMERA. OR THE MOLESKINE.

Any professional photographer can probably tell you a story about someone who saw their work somewhere and said to them, "You must have a really nice camera." Which of course insults that photographer's skill, hard work, and knowledge of photography concepts. If a nice camera was all you needed to take great photos, any jackass with $5,000 to spare could buy an expensive camera and blow us all away. But they don't.

A camera, or a stylish notebook, or a sleek laptop, are all just tools. The art comes from the person, their experiences, their knowledge of how to communicate their vision, their mastery of whatever tools they use, and their drive. A painter who has vision and drive will paint whether or not they have a beautiful studio full of canvases.

Before Jay-Z was Jay-Z, he was Shawn Carter, a

crack dealer. While standing on street corners, he would come up with rap lyrics in his head, and lacking a notebook to write them down, would run into a bodega and buy something just so he could have a paper bag to scrawl the verses on before he forgot them. He didn't wait until he could afford a new MacBook Pro.

30.

THERE IS NO ONE CLEAR PATH TO SUCCESS.

Yes, getting a story published in the *New Yorker* is a measure of success. So is recording an album that goes platinum, or writing a bestselling book. But they're not the only measures. And you shouldn't have tunnel vision on what you consider success, especially in this age of ever-evolving media. Photographer Chris Burkard has never* had a photo printed on the cover of *National Geographic.* But do you think he worries about that? Two million people see his photos on Instagram every day.

By the time you get whatever it is you think is the true mark of success, that type of media may be extinct, or on its way out. Marc Maron turned a lull in his career as a standup comedian into one of the most popular podcasts in the world because he decided interviewing people in his suburban L.A. garage was his last shot at show business success in

September 2009. Less than six years later, Maron interviewed the President of the United States in that same garage.

So keep your eyes, and your mind, open.

It is entirely possible that by the time you read this Chris Burkard will have had one of his photos printed on the cover of National Geographic.

31.

THERE IS NO GOOD ART OR BAD ART.

There's art you like, and art you don't like. Even if you hate Justin Bieber's music and believe it is subjectively terrible, millions of Justin Bieber fans would disagree with you. Does that make Justin Bieber's music good? Well, it's popular.

Some art has a very large audience (like Justin Bieber's), and some art has a very small audience. Sometimes your mom is the only person who thinks your crayon drawing is any good. That's OK. Sometimes you write a letter to affect only one person, but if that one person is affected in the right way, maybe you get married to that person. That's success, even if a million people don't think you're a great writer.

Some people make a piece of art so popular that they can't go to the grocery store to buy a loaf of bread without being recognized and mobbed by

crowds seeking autographs or photos. Some people make a piece of art that only a dozen people love, but they love it enough that it's worth it for the person who created it.

32.

WHEN SOMEONE ELSE SUCCEEDS AT DOING SOMETHING SIMILAR TO YOU, IT DOESN'T DIMINISH YOUR WORK.

Someone out there is always going to be more successful than you, have more fans than you, more Facebook likes than you, more recognition than you, and more awards than you. Hating on them isn't going to make your art any better; it's just making you look like a bitter asshole—or, if you do enough of it, it's making you actually become a bitter asshole.

If what you're doing is interesting at all, you're not doing the exact same thing as any other artist. It's not a tennis match in which you're trying to outscore someone else on a point system, so don't worry about "competing" with other people, and compete with yourself. Be a fan, a supporter, and make your own great thing.

33.

THERE IS NO SUCH THING AS "HAVING TOO MUCH TIME ON YOUR HANDS."

Sometimes, when a person sees another person doing something they deem foolish, they comment something like "they have too much time on our hands." They forget that we're privileged to have any spare time on our hands at all, something that was an unforeseeable luxury not too many generations ago, when we spent all of our time trying to survive—and something that doesn't exist at all for the often-invisible people who pick the produce we eat or make the clothes we wear in factories halfway around the world.

The advance of civilization has given many people the opportunity to have some spare time, and with that spare time, we have found ways to express ourselves. Art, whether it's Shakespeare or Picasso or *Illmatic* or *The Tonight Show with Jimmy Fallon*, is

created by people with spare time, and consumed by a much larger amount of people with spare time. Some of it we embrace, some of it we discard, and all of it, in the grand scheme of things, is arguably folly.

Charlie Todd, the founder of prank collective Improv Everywhere, once pointed out that hundreds of thousands of people get together in football stadiums on Saturdays and Sundays every fall to watch teams play games—and no one ever says, "those people have too much time on their hands."

Make art long enough (or just weird enough) and someone will no doubt accuse you of having too much time on your hands. Don't take it to heart; just remember that they probably have the same amount of time on their hands, but choose to use it differently.

34.

YOU WILL NEVER RUN OUT OF IDEAS.

Self-help author James Altucher recommends a practice of writing down ideas for a certain amount of time each day. Good ideas, bad ideas, half-formed ideas, doesn't matter—just get them out.

You may worry about running out of creativity—don't. As long as you keep cultivating that metaphorical garden of ideas in your head, they'll keep growing. So actively challenge yourself to come up with ideas—far-fetched ideas, ridiculous ideas, ideas you'd never have the skills to pull off on your own, ideas that aren't right for you, ideas you'd never have time to see through to completion, ideas you'd need thousands of dollars to finish. Don't be stingy with them. If you hang out with other creative people, give away one of your ideas (preferably one you know isn't right for you) to the right person.

Don't worry about having enough time for all of your great ideas, because you'll never have enough time. You'll make time for the right ones. As you come up with more ideas, your bad ones will get moved to the bottom of your list and eventually forgotten. Again, don't worry about them. You're not going to run out of ideas. Listen to what Maya Angelou said in a 1982 interview with *Bell Telephone Magazine*:

"You can't use up creativity. The more you use, the more you have."

35.

EVENTUALLY, YOU HAVE TO LET IT GO.

Whatever your creative project is, it's important to realize that it's not a Thanksgiving turkey—a little button isn't going to pop out when it's officially "done."

You can work on a book the rest of your life and never be happy with it, and almost every photo you ever take will have room for improvement somewhere. Leonardo da Vinci famously said, "Art is never finished, only abandoned."

The question you have to ask yourself is not if it's perfect; the question is whether it's ready. Does it say what you want it to say, the best you can say it at this point in your life? When it's ready, you can put it out there.

Don't try to helicopter parent your art. The best you can do is aim it, and hope it shoots somewhere

close to where you wanted it to go.

One more famous saying, from the wall at Facebook's headquarters circa 2012: "Done is better than perfect." Obviously you want your thing to be as close to perfect as possible, but keep your focus on getting it done, not endlessly worrying about it not being good enough. Try hard, make progress, and finish it.

36.

THERE'S A DIFFERENCE BETWEEN ART AND NARCISSISM.

When you're making whatever it is you want to make, consider why it is you're making it, and then consider why you want to share it.

We have tons of social media channels that enable instant sharing of things we can often create in seconds, and it can be easy to just share something for the sake of sharing, to get a response from our followers or friends, a small way of affirming our own existence. It's good to check your intentions before you create something, and before you put it out in front of people.

What do you want people to get out of it? What are you giving people? What's the story?

If your story is "look at me," that's not a good story.

37.

RELYING ON CLICHÉS WILL MAKE YOUR WORK CLICHÉ.

The advice to "avoid clichés" has been drummed into the heads of writers for decades—because if you say things in other writers' words, you'll never develop your own distinct voice. You don't write that your character was driving "like a bat out of hell" and "passing cars like they were standing still" and use phrases that have been spoken millions of times; you come up with you own language to describe the scene.

The same advice is useful in photography, filmmaking, songwriting, and any other creative pursuit: If you mimic the composition of a famous photo you saw on a social sharing platform, you're speaking in clichés. If you start your short film with the exact sequence of shots that you've seen in a dozen short films, you're just making the same story about different characters, or a different setting. If you catch yourself doing this, go back

and try something you haven't seen done a
hundred times.

38.

TO EXHALE CREATIVE WORK, YOU NEED TO INHALE CREATIVE WORK.

Matthew Inman, the famous creator of *The Oatmeal*, wrote in a comic in 2016: "A friend once told me creativity is like breathing. When you make stuff, you're exhaling." Inman then went on to explain that he spends a lot of time "inhaling," consuming creative work from diverse sources.

It can be a blessing and a curse to be able to go to art shows, film festivals, and bookstores and libraries and find inspiration for your personal work. Maybe you'll even feel like you're working, analyzing a certain piece for hints, or what you might do differently. Maybe you'll stay up late afterward and work on your thing.

Either way, art begets art, so absorb a wide range of other people's expressions, and you might be surprised when you see reflections of those diverse influences in your own work.

Of course, the opposite of Matthew Inman's analogy is also true—that you can't inhale forever and not exhale (if you want to create, anyway). We all only have so many hours in a lifetime, and if you spend all your free time binge-watching TV shows, you won't have time to create. So remember to exhale every once in a while.

39.

BEING SUCCESSFUL, FEELING FULFILLED, AND GETTING FAMOUS ARE NOT ALWAYS THE SAME THING.

If your No. 1 goal in making art is "getting famous," you might consider what your real calling in life is (reality TV?). If you want to make great work that eventually connects with people, make great work first and figure out how to get it out in front of the public second. Becoming famous is sometimes a side effect of making something great, but not often.

Whether or not you're a Nirvana or Foo Fighters fan, Dave Grohl had some passionate advice on musicianship in a 2013 interview with *Sky Magazine*:

"When I think about kids watching a TV show like *American Idol* or *The Voice*, then they think, 'Oh, OK,

that's how you become a musician, you stand in line for eight fucking hours with 800 people at a convention center and then you sing your heart out for someone and then they tell you it's not fucking good enough.' Can you imagine? It's destroying the next generation of musicians. Musicians should go to a yard sale and buy an old fucking drum set and get in their garage and just suck. And get their friends to come in and they'll suck, too. And then they'll fucking start playing and they'll have the best time they've ever had in their lives and then all of a sudden they'll become Nirvana. Because that's exactly what happened with Nirvana. Just a bunch of guys that had some shitty old instruments and they got together and started playing some noisy-ass shit, and they became the biggest band in the world."

40.

YOU'RE NOT TOO BUSY.

Yes, you're busy. I understand. We're all busy. Take a hard look at your day and be honest with yourself: you're filling it up with bullshit. You're being intellectually lazy, looking at your phone while you're in the bathroom, in bed when you wake up in the morning, in bed before you fall asleep at night. You watch too much TV, spend too much time analyzing sports statistics, click on too many articles about which celebrity is posting scandalous photos on social media or arguing with another celebrity, and then voila, you're out of time, the time you said you were going to use to do your creative thing.

Maybe tomorrow, right? Only if you stop wasting a few minutes here and a few minutes there doing all that useless stuff that makes us feel so "busy" nowadays.

Fuck busy and start doing your thing.

NOTES

NOTES

NOTES

NOTES

NOTES

NOTES

NOTES

NOTES

NOTES

NOTES

NOTES